The Golden Girls

STICKER ART PUZZLES

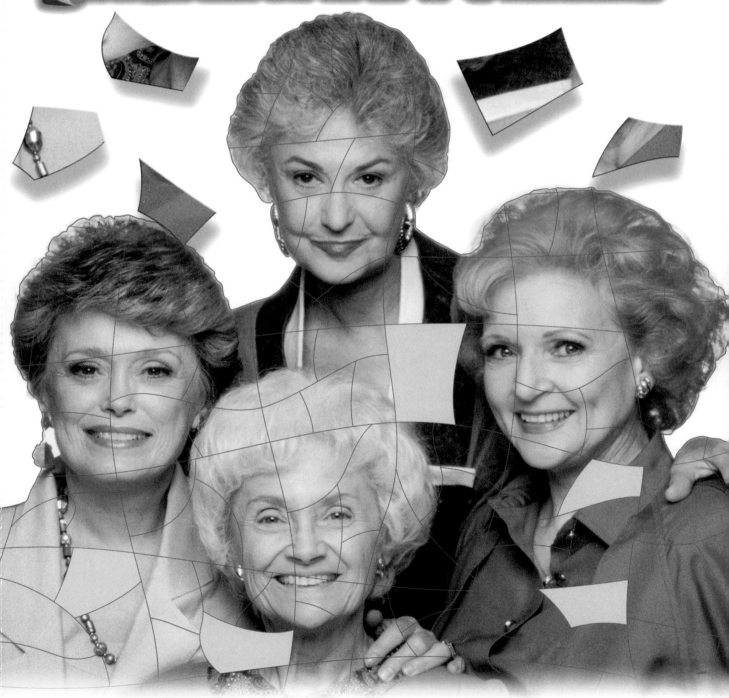

THUNDER BAY
P·R·E·S·S
San Diego, California

Thunder Bay Press
An imprint of Printers Row Publishing Group
10350 Barnes Canyon Road, Suite 100, San Diego, CA 92121
www.thunderbaybooks.com • mail@thunderbaybooks.com

Printers Row Publishing Group is a division of Readerlink Distribution Services, LLC.
Thunder Bay Press is a registered trademark of Readerlink Distribution Services, LLC.

Correspondence regarding the content of this book should be sent to Thunder Bay Press, Editorial
Department, at the above address.

Thunder Bay Press
Publisher: Peter Norton
Associate Publisher: Ana Parker
Art Director: Charles McStravick
Senior Developmental Editor: April Graham Farr
Developmental Editor: Diane Cain
Editor: Jessica Matteson
Production Team: Mimi Oey, Rusty von Dyl, Beno Chan

Produced by Judy O Productions, Inc.
Author: Arie Kaplan

Special thanks to USAopoly.

ISBN: 978-1-64517-427-1

Printed, manufactured, and assembled in Dongguan, China

25 24 23 22 21 1 2 3 4 5

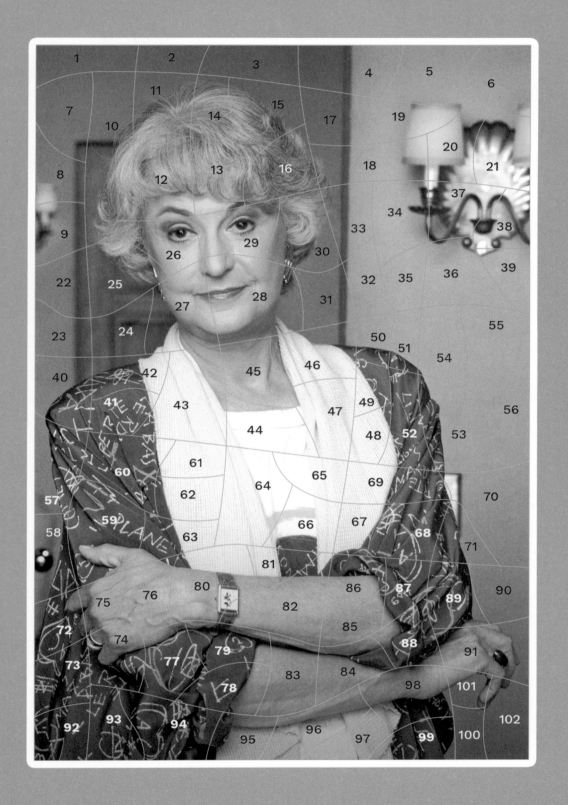

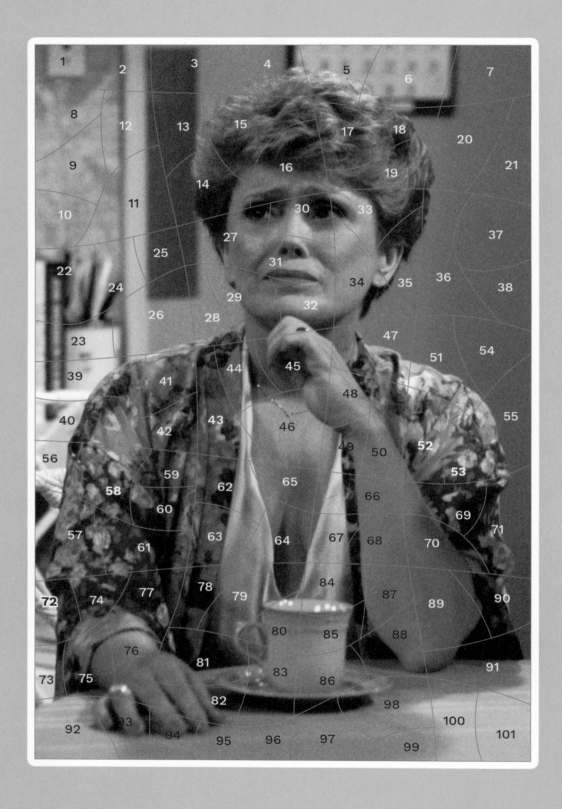

CONTENTS

INTRODUCTION

Picture it: America. September 14, 1985. Television audiences everywhere are introduced to *The Golden Girls* for the first time. Like a guy out on a date with Blanche Devereaux, those audiences would never be the same again.

The Golden Girls wasn't just another laugh-a-minute sitcom, though it did offer plenty of jokes. Audiences tuned in for the relatable characters and their richly developed relationships with one another. And at a time when good roles for women were few and good roles for women over fifty were nearly nonexistent, this series offered all of the above and then some. Dorothy, Rose, Blanche, and Sophia were four flawed, funny ladies who were always there for each other. And to keep things from sliding into syrupy sentimentality, the show's writers always threw in a heaping helping of raunchy humor.

This book contains fifteen challenging sticker puzzles featuring iconic themes from the world of *The Golden Girls*: friendship, family, aging, kitchen heart-to-hearts, and, of course, Blanche's many, many suitors. Memorable moments? They're all here. The time the ladies dressed up like birds to star in Dorothy's school play. Or when Blanche went to her high school reunion. Celebrate these "golden" moments—and more—in this sticker puzzle book!

The puzzles, with more than one hundred pieces each, reveal photos of the funniest scenes and most fashionable looks from the TV series. Use your skills to solve the puzzles! And remember: save room for cheesecake. (There's always room for cheesecake.)

INSTRUCTIONS

Each sticker puzzle features a framed outline of a hilarious lady or seminal moment from the beloved TV series. Within the outline are geometric spaces that offer hints as to where each sticker goes. You'll find the stickers starting on page 52. Apply each one to the corresponding shape in the outline, and watch as Dorothy, Blanche, Rose, and Sophia appear.

All of the pages in the book are perforated, so you can tear out the puzzle, stickers, and solutions pages to lay them out as you work. Solve the puzzles solo, or round up your own group of Golden Girls (or Golden Guys) and tackle the puzzles together.

The stickers can be moved in case you make a mistake. If you need a little help, numbered solutions for the puzzles begin on page 36.

Grab a cup of tea, curl up on your couch, and get stickering!

PUZZLES

DOROTHY ZBORNAK

The Sensible One

HUMBLE AND HILARIOUS

After divorcing her no-good husband Stanley, Dorothy Zbornak packed her things and moved in with her friends Rose and Blanche and eventually her mother, Sophia. (Yes, the same Sophia whom she regularly threatens to send back to the Shady Pines nursing home.) Friendly, humble, and good-natured, Dorothy cares a great deal for her friends. Which is not to say that they don't get on her nerves sometimes. As she said once while in a particularly foul mood, "You know, there is nothing worse than being wide awake."

CARING AND COMPASSIONATE

At the core of Dorothy's personality is her inner strength. When she's sick and scared and her physician, Dr. Budd, dismisses her symptoms and gaslights her, she eventually finds out that she has chronic fatigue syndrome. Later, she sees Dr. Budd in a restaurant and confronts him. At first he's very condescending, but Dorothy bravely persists. When she's finished telling him how his callous attitude hurt her, she finishes by saying, "You need to start listening to your patients. They need to be heard. They need caring. They need compassion." In doing so, Dorothy strikes a blow for anyone who has ever been mistreated by a doctor.

> "Go to sleep, sweetheart. Pray for brains."
> — Dorothy

STRONG AND SARCASTIC

Dorothy is the type of person who refuses to be pushed down or bullied. She's strong and defiant, which is one of the things audiences love about her. The writers frequently used her to tell stories about serious issues, which makes sense. Out of all four ladies, Dorothy looked at life in the most serious, pragmatic way. However, if that were the only side to her, she would've seemed boring and one-dimensional. It is for this reason that she was given a winning sense of humor. And you really don't want to find yourself on the receiving end of her sarcastic zingers.

GOLDEN nugget

When Dorothy worked as a high school substitute teacher, her nickname was "Attila the Sub."

> "You truly are one chromosome away from being a potato."
> — Dorothy

GOLDEN gems GOLDEN gems GOLDEN gems GOLDEN gems

Q: How many years were Dorothy and Stan Zbornak married?

Q: What was the name of Dorothy's daughter?

6

Flip to the inside front cover flap for Golden Gems answers.

> **IT'S LIKE LIFE IS A GIANT WEENIE ROAST, AND I'M THE BIGGEST WEENIE!**

ROSE NYLUND

The Nice One

NAIVE NYLUND

While Rose Nylund might not be the sharpest tool in the shed, she's good-natured, upbeat, caring, and beloved even if the other ladies in the house can't always muster the patience Rose's ways often require. To spend any length of time with Rose is to see why: she can be breathtakingly naive. This has led to the roommates' frustration, such as when she asked Dorothy, "Can I ask a dumb question?" And Dorothy replied, "Better than anyone I know." Rose is from the small town of St. Olaf, which she speaks of often, telling her friends about the town's bizarre customs and even more bizarre sayings.

> ### "It's like we say in St. Olaf, 'Helgenbargenflergenflurfennerfen!'"
> — Rose

AIMLESS ANECDOTES

The other women sometimes overlook Rose because of her scatterbrained nature and aimless anecdotes, but sometimes those anecdotes can get them out of a jam. When Dorothy, Blanche, and Rose are mistaken for prostitutes, they're put in a jail cell with actual prostitutes, who are quite confrontational and angry. While in the cell, Rose tells Blanche and Dorothy a story about how she was cheated out of becoming the Butter Queen of St. Olaf. The story keeps her friends occupied, and it's such a gripping yarn that it also entertains the prostitutes until Sophia arrives to bail everyone out.

FRIENDLY AND FLAWED

Rose's biggest flaw is her desire to be liked by everyone. This sometimes leads to others taking advantage of her, and her friends worry about this. However, Rose can be surprisingly present, and she notices more than her roommates think. When Blanche asked Rose, "What was your first impression of me?" Rose replied, "I thought you wore too much makeup and were a slut. I was wrong. You don't wear too much makeup."

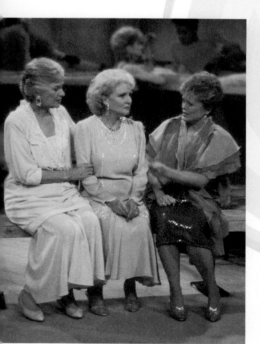

> ### "I'm not one to blow my own vetugenfluke."
> — Rose

GOLDEN gems **GOLDEN** gems **GOLDEN** gems **GOLDEN** gems

Q: What did Rose mistakenly give her babies for colic?

Q: What were Charlie and Rose doing when he suffered a fatal heart attack?

10

Flip to the inside front cover flap for Golden Gems answers.

SOPHIA PETRILLO

The Wise One

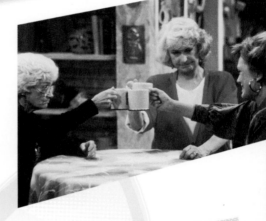

ZESTY ZINGERS

When the Shady Pines retirement home burns down, Sophia moves in with her daughter Dorothy and her friends. With her slight, wiry frame, Sophia may look like a weak old woman. But she is a force to be reckoned with, and no one is safe from her rapid-fire insults. When Blanche is talking about her new beau, she says that when they're together, they laugh a lot. Sophia replies, "Why wouldn't you? You're both naked." Sophia's full of stories about the old country, and these tales frequently begin with the words, "Picture it," as she paints a portrait of her homeland of Sicily, which (to hear her tell it) was a land of intrigue, danger, and more danger!

SOPHIA THE SCHEMER

Sophia is nothing if not a schemer. When she plans to hold her own wake, she thinks that everyone will say nice things about her. However, when Rose sends out the invitations, she forgets to say that Sophia's still alive, so the attendees think she's really dead, and they're appropriately upset. And they're even more upset when they see Sophia alive. Sophia's plan has gone up in smoke. "I wish my wake hadn't been such a disaster," she frowns. Dorothy consoles her mother by saying, "Well, look on the bright side. You'll have another one."

> "May the bags under your eyes grow so large your head falls in 'em!" — Sophia

COMPLEX AND CRITICAL

Sophia's relationship with her daughter is a complex one. On one hand, Sophia calls Dorothy "pussycat," and she clearly loves Dorothy. On the other hand, Sophia reserves many of her most withering quips for Dorothy. As Sophia once said to her daughter: "Jealousy is a very ugly thing, Dorothy, and so are you in anything backless." This mirrors the complex dynamic many real-life parents have with their children. The same could be said for Sophia's constant criticism of Dorothy's status as a divorced-and-now-unmarried woman. Sophia represents the older generation, and in her day, it was unthinkable to reach Dorothy's age without being married. Although it's sometimes hard for her to express it, she criticizes because she cares. Sophia's views on life may be old and moldy, but her love for her daughter is very much in season.

GOLDEN nugget

Sophia's brother Angelo pretended to be a priest for seventy-two years.

> "Your heart's in the right place, but I don't know where the hell your brain is." — Sophia

GOLDEN *gems* GOLDEN *gems* GOLDEN *gems* GOLDEN *gems*

Q: When a sandwich vendor named Johnny No-Thumbs leaned on Sophia, who did she call on for help?

Q: How many children did Sophia's son Phil have?

12

Flip to the inside front cover flap for Golden Gems answers.

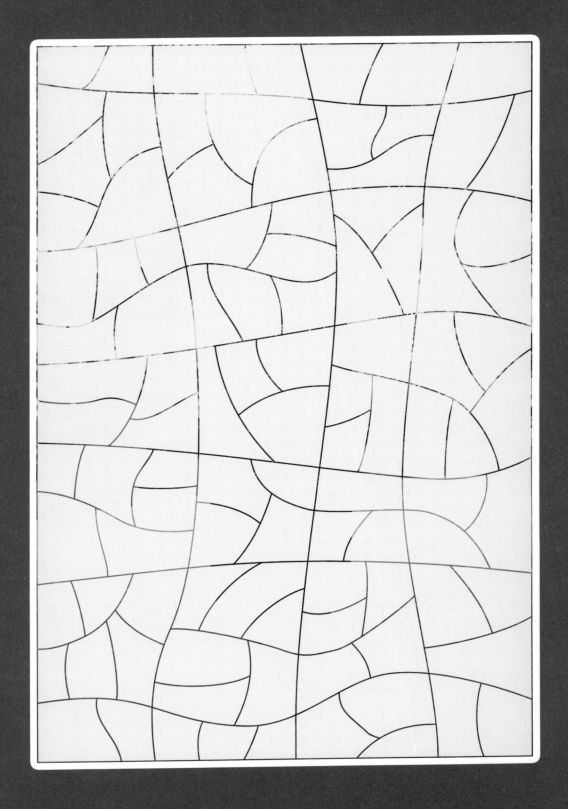

GOLDEN FRIENDSHIP

REALISTIC RELATIONSHIPS

Dorothy, Blanche, Rose, and Sophia have a friendship that audiences find refreshing most simply because it's realistic. That is, it involves all of the fighting, misunderstanding, petty jealousy, and competitiveness that most real-life friendships endure. They may go to a therapist to deal with their distaste for one another, but it speaks highly of their relationship that they attend these sessions together. Underneath it all, they want to work things out, and they usually do.

STRONG SISTERHOOD

Despite the catty insults they sometimes lob at one another, these women are true sisters.

"Eat dirt and die, trash!" — Blanche

When Rose falls in love with a man named Buddy, something about him doesn't quite sit right with Dorothy. So she does research on Buddy and finds out that much of what he's telling Rose is a lie and he's planning on conning her out of her money. Eventually, Rose takes care of everything herself and realizes her friends are always there for her, just in case she needs them.

"Buzz off." — Dorothy

ALTRUISTIC AND AWARE

Sometimes, the women's friendship is used by the show's writers to highlight important social issues, like homelessness. After the girls discover that they have a winning lottery ticket, Sophia accidentally puts the ticket into a box with clothes she donates to the Mission Street Shelter. So all four ladies spend the night at the shelter to find the ticket. However, after befriending the homeless people there, the women decide to donate the lottery ticket to the shelter. They make the donation as a group, and their friendship emboldens them in performing this selfless act.

GOLDEN nugget

Rose often calls her sometimes-sour roommates "Gloomy Guses."

"Why do blessings wear disguises? If I were a blessing, I'd run around naked."

— Sophia

Q: After her broken engagement in the pilot episode, who did Blanche consider to be her family that made her "happy to be alive"?

Q: While winning the "Best Friend of the Year" award, who said, "When you're lucky enough to find that kind of friendship, I guess you just want to pass it on"?

14

Flip to the inside front cover flap for Golden Gems answers.

BACK IN ST. OLAF

SCATTERBRAINED STORYTELLER

Anyone who knows Rose knows she shouldn't be encouraged to tell stories about what it was like growing up in the quirky hamlet of St. Olaf, Minnesota, with its eccentric customs and even more eccentric townsfolk. Not that she needs the encouragement. She usually offers up these tales all on her own, since she clearly loved living there. But that doesn't mean her roommates love hearing

SPECIMEN OF SILLINESS

Rose seems to be a typical inhabitant of St. Olaf, whose residents aren't exactly known for their intellectual prowess. When Rose is chosen as the town's "Woman of the Year," three people from St. Olaf (Len, Sven, and Ben) come to give her the good news. Len, Sven, and Ben are triplets, but they don't look anything alike. However, the other people in St. Olaf couldn't tell them apart. Still, Rose is very proud to be from St. Olaf, and the town occupies a special place in her heart.

> ### "It's like we say in St. Olaf: Christmas without fruitcake is like St. Sigmund's Day without the headless boy." —Rose

about St. Olaf, and as soon as she begins with, "Back in St. Olaf," the other ladies know that she'll be telling them one of the strangest, goofiest, and most nonsensical stories they've ever heard.

UNUSUAL AND UNFAMILIAR

The way Rose tells it, to celebrate Easter in St. Olaf is to drink eggnog while wearing a cast-iron bra. To play team sports in St. Olaf is to whack oneself over the head with a baseball bat. And in the rest of America, you might be familiar with conflicts like the Civil War or World War II. But only in St. Olaf would you learn about the Great Herring War, which seems to have confined itself to that tiny Minnesota town. (Thank goodness for that!) In making St. Olaf the home of such odd customs and holidays, *The Golden Girls* writers are satirizing the way many Americans think of cultures with which they're unfamiliar. For some people, to encounter someone from another country is almost akin to making contact with a space alien. . .or someone from St. Olaf.

GOLDEN nugget

When citizens of St. Olaf turn fifteen, they sign a pledge promising not to do anything wild, crazy, or impetuous.

> ### "But still, St. Olaf's town motto was "Better Ned than Red." Ned was sort of the town idiot." —Rose

> ### "When, on your days off?" —Sophia

GOLDEN gems GOLDEN gems GOLDEN gems GOLDEN gems

Q: Which of Rose's uncles died and left her a pig and $100,000 if she cared for it as long as it lived?

Q: Back in St. Olaf, what did Rose feed her lamb to make it heavier for the county fair?

Flip to the inside front cover flap for Golden Gems answers.

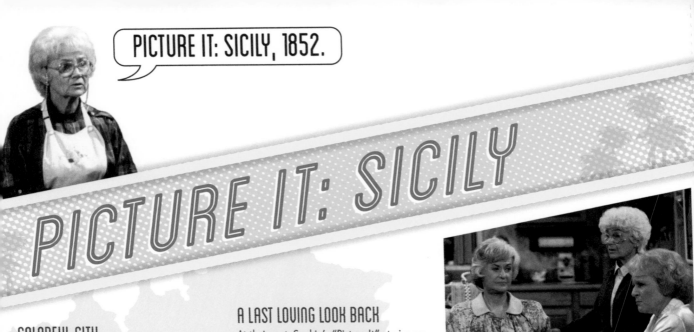

PICTURE IT: SICILY, 1852.

PICTURE IT: SICILY

COLORFUL CITY

According to Sophia, her hometown of Sicily is a...colorful place. How else to describe what was home to a popular game show called Torture, hosted by the fascist dictator Mussolini? Whenever one of the girls are in need of sage advice, Sophia is there with a parable about Sicily that is meant to teach a valuable life lesson.

AUTOBIOGRAPHICAL ADVENTURES

Often, Sophia's "Picture It" stories turn out to be about herself in some roundabout way. At one point she tells the others about a beautiful young peasant girl in Sicily in 1912, who is romanced by an exciting penniless painter. The relationship ends badly, and at the end of the story, Sophia reveals that she was the peasant girl, and the painter was Pablo Picasso. Dorothy says that her mother is lying. Rose tells the ever-cynical Dorothy to be positive. So Dorothy turns back to her mother and says, "Okay, I'm positive you're lying."

"Picture this: two young girls who shared three things—pizza recipes, some dough, and a dream." —Sophia

A LAST LOVING LOOK BACK

At their root, Sophia's "Picture It" stories are a metaphor for how our immigrant forebears will often look fondly on the customs and traditions of their homeland, even when those customs and traditions are associated with dramatic or even tragic events from their past. After all, hindsight is twenty-twenty. Sometimes those stories are also an excuse for Sophia to show her more warmhearted side, as when she gives the ladies' next-door neighbor an "evil eye" after he gives them a hard time about moving a tree that falls into their yard. The evil eye in this case is a Sicilian curse Sophia learned about long ago, but she's using that curse to protect her loved ones.

GOLDEN *nugget*

Sophia claims to have been the only girl in her village who didn't want to be a nun.

"To her trio of suitors, that eventful gathering was referred to as 'Rendezvous with Sophia.' But to the rest of the world, it was better known as 'The Yalta Conference.'" —Sophia

GOLDEN *gems* GOLDEN *gems* GOLDEN *gems* GOLDEN *gems*

Q: What is the name of Sophia's sister from Sicily?

Q: What family did the Petrillos have a vendetta against, until they all died from sausages they shouldn't have eaten?

THE KITCHEN TABLE

CONGREGATE AND COMMISSERATE

No matter what time of day it is, the women usually congregate in the kitchen, where they air their grievances with one another, share their triumphs and tragedies, or make up after a disagreement. The kitchen is a perfect "neutral zone" for them to plot, plan, talk about relationships, or just eat a slice of cheesecake. So. Many. Cheesecakes!

KITCHEN COMBAT

Sometimes, the kitchen becomes a battle zone of sorts. When Blanche goes on a "sensible meals" diet and goes into the kitchen to retrieve one of her pre-prepared meals, she sees the other four ladies baking sugary cakes and finds it difficult to summon the inner strength and stick to her diet. Then comes the corker: Rose has accidentally eaten one of Blanche's sensible meals, and she also washed it down with one of Blanche's sensible shakes! Blanche shakes Rose violently, until Dorothy makes her stop. Blanche then leaves

to go collect herself. Thus we see that the kitchen can be a place of war as well as a place of peace.

"Wake up and smell the coffee, you fossil!" —Sophia

SAFE SPACE

The kitchen is the original "safe space," a place where anyone can say what's on their mind. That's not to say that the person they're saying it to won't take offense, and many fights have been instigated in the kitchen. However, those fights are usually also ended in that very same kitchen soon afterward, over a few slices of (you guessed it) cheesecake. Many real-life families have a place like this, a certain area of their house or apartment where grievances are aired and problems are sorted out.

GOLDEN nugget

Cheesecake is more than a dessert the girls all happen to enjoy; it's what they bonded over when they first moved in together.

"I need cheesecake." — Blanche

"Do you know how many problems we've solved over a cheesecake at this kitchen table?" — Dorothy

"One hundred and forty-seven." — Blanche

nsGOLDENgemsGOLDENgemsGOLDENgemsGOLDENgemsGOLDENgemsGOLD

Q: Who won a giveaway, claiming, "all those endless hours licking stamps, licking envelopes, temporarily losing the ability to taste sweets" had been worthwhile?

Q: What type of cheesecake did Rose get the night Dorothy discovered she was attracted to a priest?

Flip to the inside front cover flap for Golden Gems answers.

THE KITCHEN TABLE / Stickers on page 68. Solution on page 44.

21

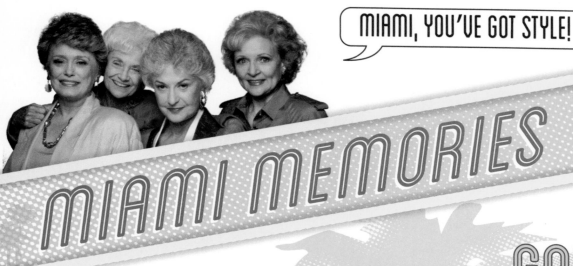

MIAMI MEMORIES

CITY AS CHARACTER

Miami isn't just a beautiful backdrop for the series, and it's not just the place the ladies call home. It's almost a character of its own, a fifth Golden Girl, if you will. Often, the women can be found out on the lanai, enjoying the balmy breeze and the gorgeous blue sky. Or they can be found indoors, with palm fronds visible in the windows. The tropical Miami weather also dictates the types of clothes the ladies wear. Obviously, in this heat, colorful and flowy garments are the way to go. Any way you slice it, Miami is ever-present throughout the series.

"Miami is nice, so I'll say it twice!"

—Dorothy

MIAMI MELODY

Sometimes, the plot of a *Golden Girls* episode will directly involve the city of Miami. When Dorothy and Rose enter a songwriting contest, their goal is to write a jingle about the city. Their songwriting partnership gets off to a rocky start as they bicker about the song's lyrics. But eventually they figure out how to successfully collaborate and they submit their song. They don't win the contest, but they play the entire thing for Blanche and Sophia. The song, "Miami Is Nice," is a poetic paean to a town whose nickname is Magic City, featuring lines like, "Miami, Miami, you've got style! Blue skies, sunshine, white sand by the mile!" It's a fitting tribute to Dorothy and Rose's adopted hometown.

A MATCHED SET

Audiences think of Miami and *The Golden Girls* as the perfect pair. You can't have one without the other. The series simply wouldn't work if it were set in a different city. Can you imagine *The Golden Girls* if it took place in New York City or Dallas? It would feel... wrong somehow. And yet, Miami provides the perfect backdrop for this series. When the ladies are going through a crisis, Miami's beautiful weather soothes their spirits. When they're celebrating a triumph, where better to rejoice than at a Miami hotspot? This city truly adds personality to this quartet of characters.

GOLDEN nugget

The women's house is located at 6151 Richmond Street.

"Dorothy, can I borrow your mink stole?"

—Blanche

"It's Miami in June—only cats are wearing fur!"

—Dorothy

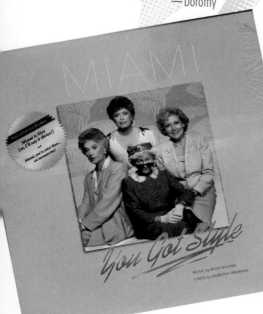

GOLDEN *gems* GOLDEN *gems* GOLDEN *gems* GOLDEN *gems*

Q: What delicatessen did the ladies often patronize?

Q: Where did Uncle Angelo move into, when he came to Miami?

Flip to the inside front cover flap for Golden Gems answers.

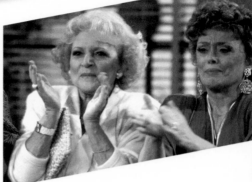

> ANYWAY, HENNY PENNY, BEING A CHICKEN, NOT THE BRIGHTEST BIRD IN THE WORLD, IMMEDIATELY JUMPED TO THE WRONG CONCLUSION.

GOOFY GIRLS

"No, I will not have a nice day!"
— Dorothy

SILLY SITUATIONS

Because these four ladies are friends, they also have a habit of getting into awkward situations together. And because their personalities aren't always an exact match—sensible Dorothy might disapprove of something naive Rose has done, for example—this leads to conflict, drama, and of course hilarity. The goofiest moments in *Golden Girls* history are the ones involving the ladies doing silly things, sometimes dressed in even sillier costumes.

it with adults. The play is Henny Penny, the story of a hen who convinces her barnyard friends that the sky is falling. Which adults does Dorothy get to perform in the play? Why, Dorothy herself and her three roommates, of course! Cut to Rose in a hen costume as Henny Penny, Blanche in a goose outfit as Goosey Loosey, Dorothy in turkey garb as Turkey Lurkey, and Sophia in a Peter Pan-style costume as the fairy-tale narrator. True friendship is donning feathers and dancing around a stage for your friend.

BIRDS OF A FEATHER

These ladies go above and beyond for one another, even when it means putting themselves in a ridiculous situation to do it. When the kids who are supposed to be performing Dorothy's school play all get sick, she needs replacements and decides to recast

SELFLESS AND SILLY

It says a lot that these four ladies can truly be themselves around each other, warts and all. They're willing to forego their own dignity and look foolish because, sometimes, that's what friends do. And it makes for great television. But it also rings true. In real life, many of us put our own egos on hold when we need to help our friends. And it's good that a show like this, which portrayed self-sacrificing women who had depth and strength of character, was available to the public at a time when such portrayals were not the norm.

GOLDEN nugget

Rose once tried to get Dorothy to join a positive-thinking group called "Create Your Own Miracles."

"I've been having a good time, and there wasn't even a man in the room."
— Blanche

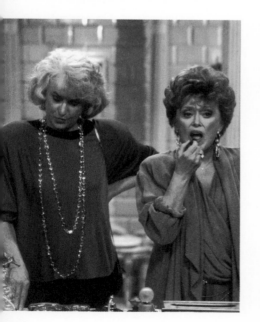

GOLDEN *gems* GOLDEN *gems* GOLDEN *gems* GOLDEN *gems*

Q: Who was better in dirty dancing class, Rose or Blanche?

Q: Who began renting X-rated movies when the girls got a VCR?

Flip to the inside front cover flap for Golden Gems answers.

SASSY GIRLS

HUMOR AND HEART

A massive part of *The Golden Girls*'s appeal is the show's feisty sense of humor! Each of the ladies can be as sassy as a madam. When the girls aren't making snide remarks about Blanche's love life or Dorothy's lack of same, they're being a little too candid about Sophia's advanced age or Rose's naivete. It's true—these four friends love taking jabs at one another. But since it comes from a place of genuine love, they never alienate the viewers, who know that they have each other's backs, no matter what.

DIVA DRAMA

Sometimes this Miami foursome's sassiest moments come when you'd least expect them. When Dorothy goes on a cruise, she leaves Sophia in Blanche's care. As Dorothy leaves, her mother sweetly says, "Goodbye, pussycat." Then she turns to Blanche and grins, "Fasten your seatbelt, slut puppy! This ain't gonna be no cakewalk!" At that point, what was a nice moment becomes fraught with conflict. The lesson: whenever you put at least two Golden Girls in a scene, drama and hilarity will follow in equal measure.

BOLD AND BRASSY

Sexually charged jokes are a big part of the show's sassy DNA. When *The Golden Girls* first premiered, the idea of older women speaking frankly about sex was a bold concept. They said things that women of a certain age weren't "supposed" to say. But the fact that these ladies were talking about their romantic lives in an explicit manner gave this show a real cross-generational appeal. These characters said out loud what audiences were thinking.

GOLDEN *nugget*

For her homemade gift to the other girls, Blanche made a copy of a calendar called "The Men of Blanche's Boudoir."

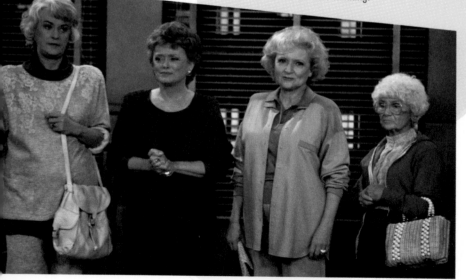

"If this sauce was a person, I'd get naked and make love to it." — Sophia

"I could get herpes listening to this story!" — Dorothy

GOLDEN *gems* GOLDEN *gems* GOLDEN *gems* GOLDEN *gems*

Q: What was the surname of the triplets who once fought over Blanche at a barbecue?

Q: Who said, regarding their husband's sleeping habits, "His side of the bed looks like a murder took place"?

Flip to the inside front cover flap for Golden Gems answers.

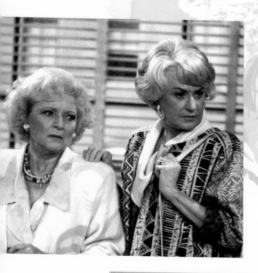

> HE WAS MORE LIKE A FIVE, BUT HE LOOKED SO GOOD WITH ME ON HIS ARM, I ADDED TWO POINTS.

STYLISH GIRLS

FABULOUS AND FASHIONABLE

These four ladies always make sure they're dressed in the most stylish way possible, whether they're just lounging around the house, busy at work, or out on a date. You can usually find them decked out in the height of 1980s Miami fashion, which generally means plenty of flowing caftans, colorful prints, sparkly accessories, and padded jackets.

STYLISH STORIES

Just as Miami sometimes informs *The Golden Girls* story ideas, the ladies' fashion sense occasionally inspires episode plotlines as well. When Dorothy is getting dolled up to go to a museum fundraiser banquet, she wears a very stylish dress. Blanche then unveils the dress she bought for the event. And it's the same one! "Dorothy, this is crazy," Blanche pleads. "Since when do you care about how you look?" Dorothy's acid-tongued reply: "I think it started when I came down from the bell tower and had my hump fixed." Then when Blanche gets a new dress, she doesn't realize that her new dress is the same as Sophia's outfit!

> ### "Crying is for plain women. Pretty women go shopping."
> — Blanche

CHIC CHARACTERS

The four ladies are known for their different looks. Rose is partial to pretty dresses and quirky sweatshirts. Dorothy is notorious for her turtlenecks. Sophia is most at home in cardigans. And Blanche is a Devereaux Diva in her glittering dresses, jackets, and jewelry. But the show goes out of its way to tell us, in episode after episode, that these women aren't stereotypical clotheshorses. They're far more multidimensional than that. That having been said, their fashion choices do provide an extra window into their personalities.

GOLDEN nugget

Blanche once told Dorothy that the design of the best dress she owned "does tend to accentuate your behind while simultaneously diminishing your cleavage."

> ### "To the untrained eye, that polyester can almost pass for silk!"
> — Blanche

GOLDEN gems GOLDEN gems GOLDEN gems GOLDEN gems GOLDEN gems GOLD

Q: Who said, "That's the trouble with being beautiful. The maintenance will kill you"?

Q: Who understood how Stan was like Sophia's shoes, in that "he may not be stylish, but he's familiar, he's comfortable"?

28

Flip to the inside front cover flap for Golden Gems answers.

YOU'LL HAVE TO EXCUSE MY MOTHER. SHE SUFFERED A SLIGHT STROKE A FEW YEARS AGO, WHICH RENDERED HER TOTALLY ANNOYING.

FOUND FAMILY

Family is a core theme of *The Golden Girls*, which isn't surprising given that the series is about a found family of friends who function as a support network for one another. Dorothy, Blanche, Rose, and Sophia are advisors, caretakers, counselors, and peacemakers for one another. They commiserate over comfort food (like the aforementioned cheesecake) as they talk out their problems. That sounds a whole lot like a family.

> *"No one in my family has ever seen a psychiatrist—except of course, when they were institutionalized!"*
>
> — Blanche

KITH AND KIN

One actual, related-by-blood family unit (a small one, anyway) is in every episode of *The Golden Girls*, and that's the mother-daughter pair of Sophia and Dorothy. But throughout the series we're also introduced to Dorothy's other relatives, as well as Rose's and Blanche's family members. When Blanche's brother Clayton reveals that he's gay, at first Blanche isn't very accepting. But eventually she comes around. Clayton tells her he's the same person he always was. She says, "No, you're not. You used to be just like me." When Clayton mentions that he's great looking, charming, and irresistible to men, Blanche realizes, "My god, Clayton, you are me!"

SERIOUS SUBJECTS

As we've seen with the episode where Blanche's brother comes out to her, *The Golden Girls* sometimes introduced previously unseen family members as a way to explore monumental themes on the show. That episode with Clayton first aired in 1988, and at the time, there were very few LGBTQ characters on television. *The Golden Girls* was one of the only shows in the 1980s to even tackle the subject of coming out. And by making the episode all about Blanche and her baby brother, the series tied the subject in to its core theme of family.

> *"When your crazy cousin Nunzio started living with his pet goat, did the family turn their back on him? No. And after a couple of nights neither did the goat."* — Sophia

Q: What was the name of Dorothy's goddaughter?

Q: When Blanche was a little girl, what was her mother's nickname for her?

Flip to the inside front cover flap for Golden Gems answers.

GROWING OLD TOGETHER

"Oh, c'mon, Blanche. Age is just a state of mind." — Dorothy

"Tell that to my thighs." — Blanche

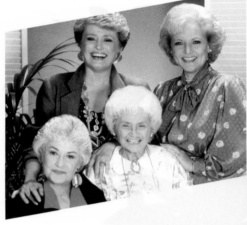

SUPPORT SYSTEM

Throughout the series, the women offer emotional support to one another as they face the physical obstacles that present themselves as one ages. Of course, the fact that they're growing older doesn't slow down their romantic lives, nor does it stop them from contributing to society as active members of the workforce. However, the topic of aging is one that rears its liver-spotted head every now and then.

LIFE LESSONS

When Blanche thinks she's pregnant, she goes to the doctor and finds out that—in fact—she is going through menopause. This upsets her because she feels it's a sign that she'll no longer be attractive to men. Thinking that her life is pretty much over, she sees a therapist, who helps her through this difficult milestone. But she really begins feeling better shortly after, when a handsome veterinarian visits the ladies. Blanche flirts with him, which prompts Sophia to mutter, "The 'change of life' didn't change her life!" In other words, Blanche is still the same person she's always been, and getting older hasn't affected her personality or pursuits one bit.

NIMBLE AND NUANCED

The way aging is presented on *The Golden Girls*, it is just one of many things you go through during your life. As such, these four women are never portrayed as slow or feeble, a marked contrast to the way aging can sometimes be dramatized. Rose might be slow-witted, but it's very clear that this is not a by-product of the aging process; it's just the way she's always been, even when she was growing up. The other three women couldn't be more quick-witted, even Sophia, who is older than the rest and who is a stroke survivor.

GOLDEN nugget

Blanche convinced the governor to delete all records of her age on official documents. That way, nobody would know how old she is.

"Do you know what the worst part about getting older is?" — Blanche

"Your face? Rose's hands?" — Dorothy

GOLDEN gems GOLDEN gems GOLDEN gems GOLDEN gems GOLDEN gems GOLD

Q: Who opted against plastic surgery, saying, "Besides, I can live with the lines and wrinkles and sagging, as long as I have you three to grow old with"?

Q: Who was grateful to Fidel because "he awakened feelings in me I haven't felt in thirty-five years"?

32

Flip to the inside front cover flap for Golden Gems answers.

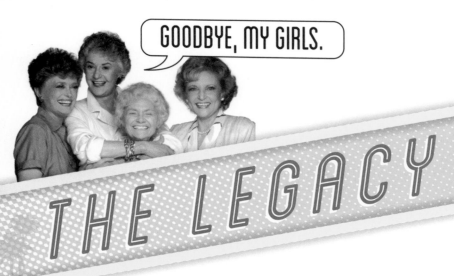

GOODBYE, MY GIRLS.

THE LEGACY

NOT-QUITE-NUPTIALS

In the pilot episode of *The Golden Girls*, back in 1985, Blanche almost gets married, and it looks like she's going to leave her roomies to go live elsewhere. But her hubby-to-be turns out to be a bigamist and a swindler, and he gets arrested before the ceremony even begins. In the hour-long series finale in 1992, Dorothy pretends to get engaged to Blanche's uncle Lucas. Audiences no doubt thought it would only be a ruse, a thematic variation on Blanche's not-quite-marriage from the pilot. However, fans were surprised when Dorothy actually goes through with her marriage to Lucas.

DOROTHY'S DESTINY

The show ends with Dorothy getting ready to move to Lucas's estate in Atlanta, Georgia. Sophia considers joining her daughter in

Georgia, but eventually she decides to stay in Miami with Blanche and Rose. In the series' final minutes, there's a tearful goodbye between Dorothy and her roommates. Everyone gathers together for a group hug. And what could be a saccharine moment really works here, simply because the emotions are earned. We've been through a lot with these characters throughout seven seasons and 180 episodes. They're well-written characters, portrayed by iconic actors, so when it's time to say goodbye to them, we get a lump in our collective throats.

"Oh, my god. Who died? Did one of us die?" —Sophia

TIMELESS AND TRIUMPHANT

The Golden Girls fills a very special role in the pop-culture pantheon. By being one of the few shows during the 1980s with a main cast made up of women over fifty, and breaking countless boundaries, it earned the respect of its audience. And by being a show that specialized in bawdy, raunchy humor, it was a show that young people were eager to watch, often alongside their parents or grandparents. In this way, it was a rare series that bridged the generation gap. The show's humor, characters, and themes were universal ones, and that's why the show is still revered today. It's a series about how magical it is to have friends who truly understand you. As Dorothy says to her three friends as she leaves Miami, "You're angels. All of you."

GOLDEN nugget

Lucas's Atlanta estate is known as Hollingsworth Manor.

"Is it my stroke, or did they do this already?" —Sophia

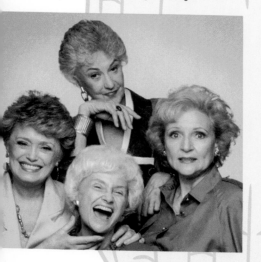

Flip to the inside front cover flap for Golden Gems answers.

SOLUTIONS

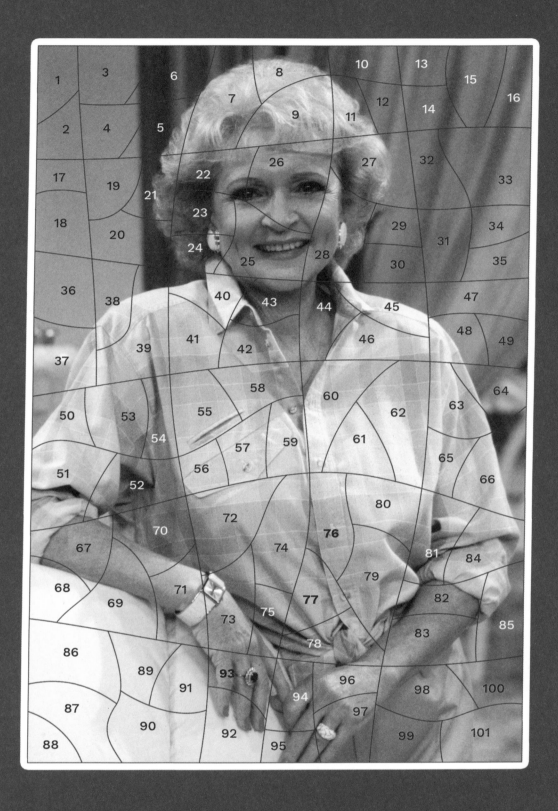

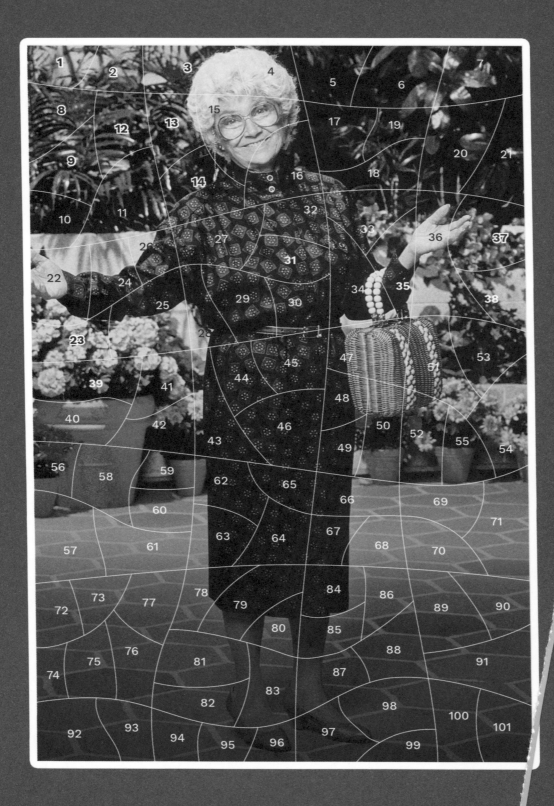

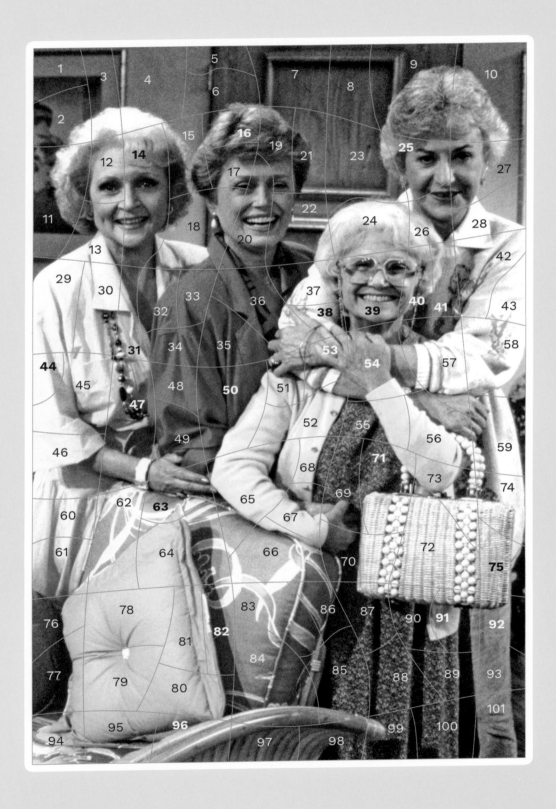

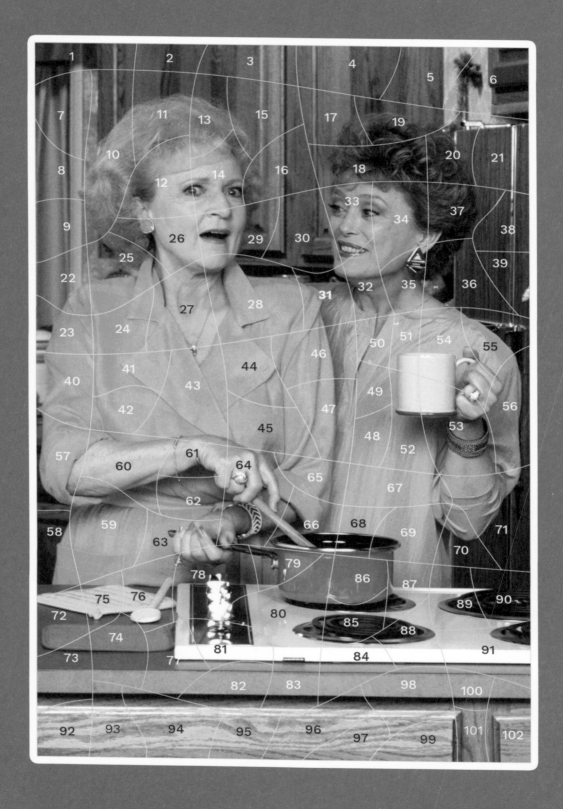

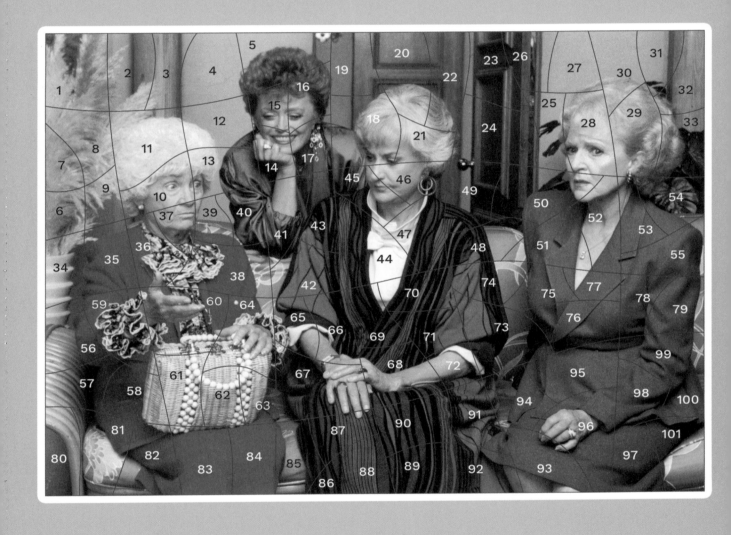

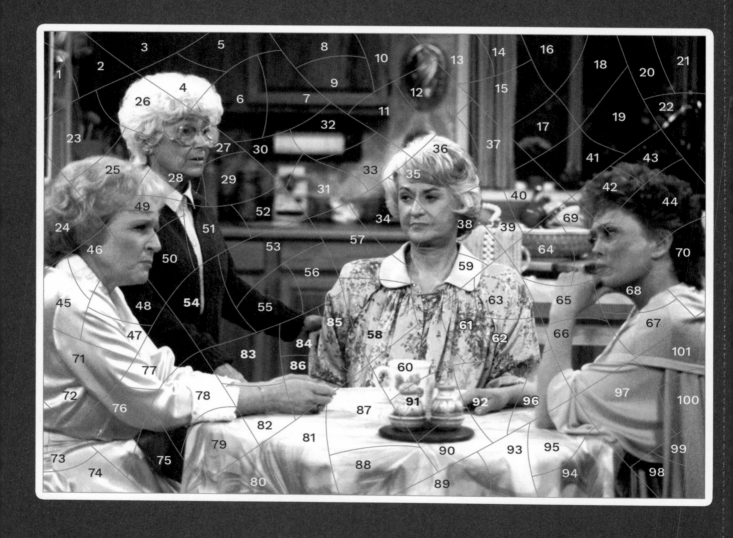

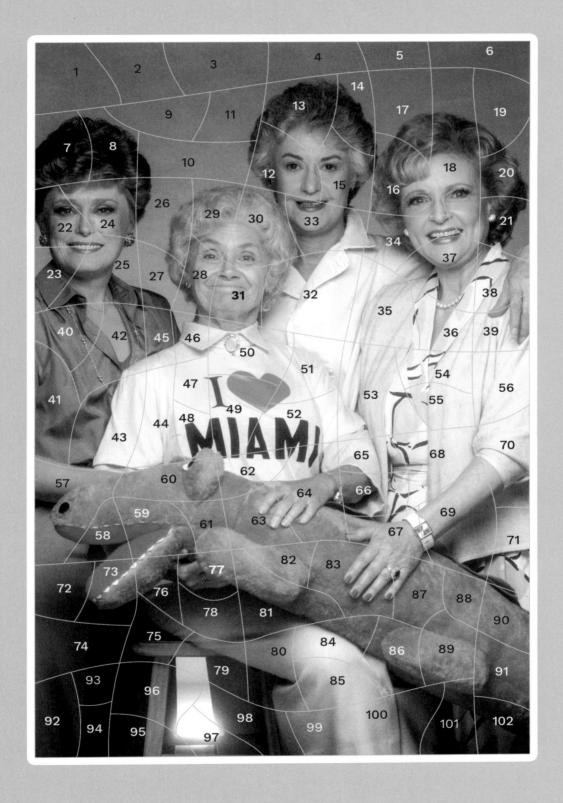

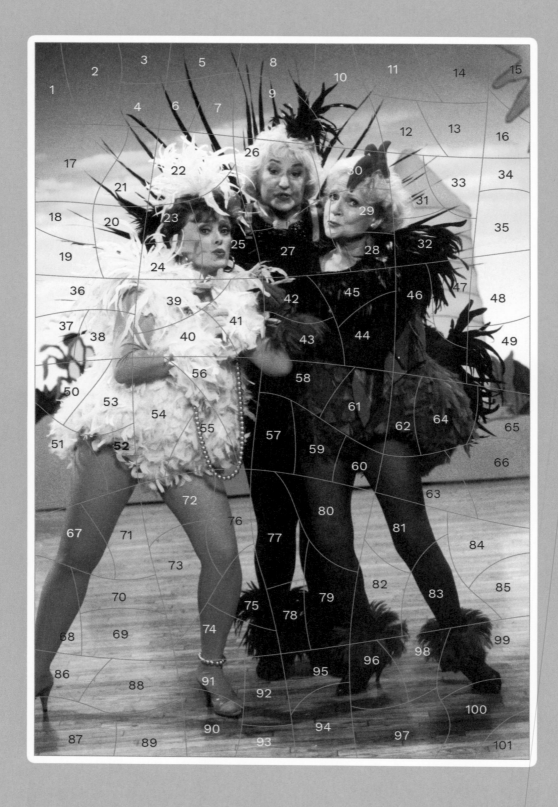

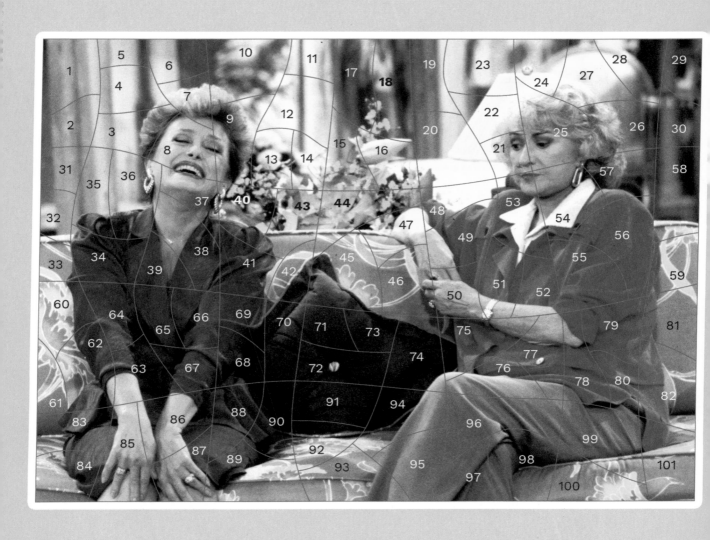

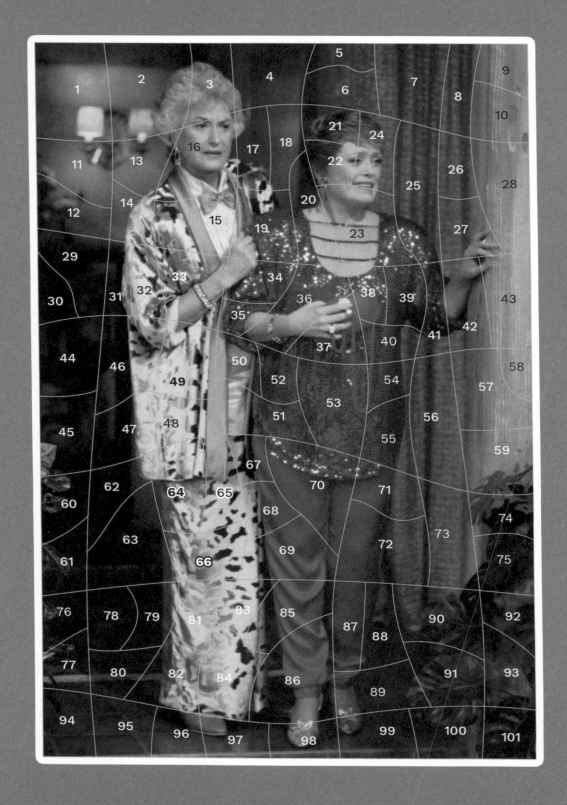

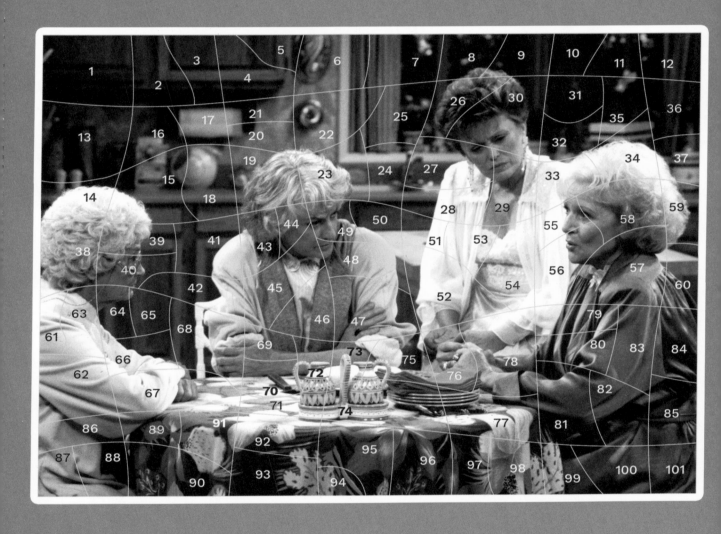

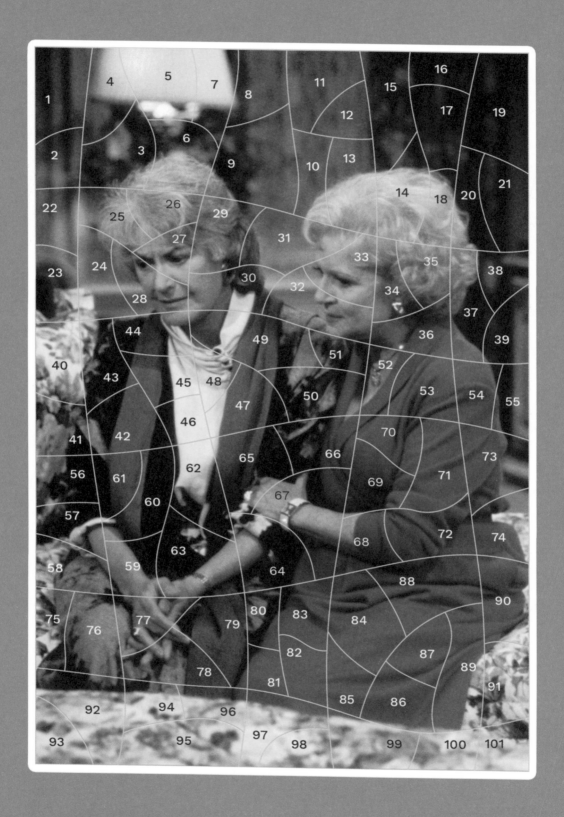

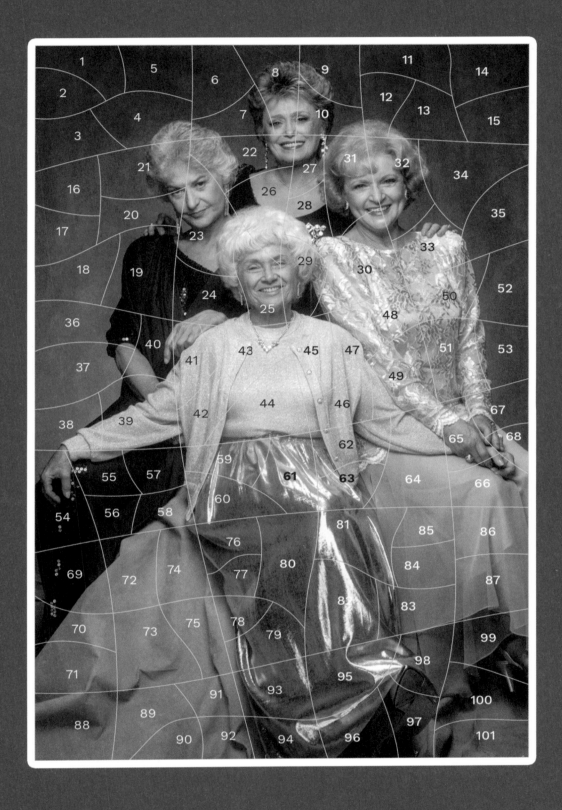

STICKERS

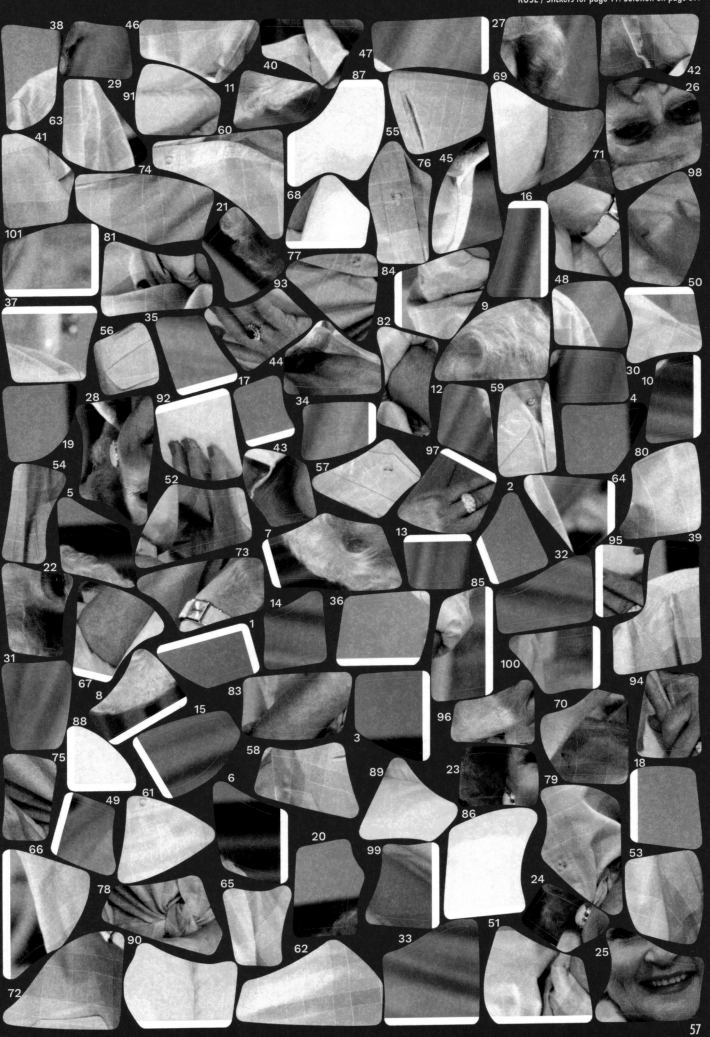

43 77 55 9 17 35 50

51 67 85 79 20

46 25

10 15 42 89 19 12 64

16 59 34 58 24 82 38 36 96

83 40 48 62 27 30 61

53 97 6 44 72

37 13 60

18 32 31 54 4 73

41 100

88 68 21 45 87

76 57 23 2

65 66 47 56 70

75 95 5 74

39 22 7 1 71

90 102

02 11 94 49 26 84

69 29 99 33

3 63 91 86 8

52 28

78 80

98 93 101 81

14